Rad Art

Rad Art

A Journey Through Radiation Treatment

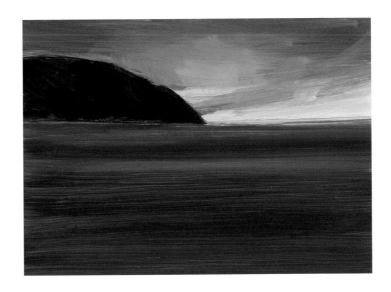

Written and Illustrated by Sally Loughridge

Published by the American Cancer Society
Health Promotions
250 Williams Street NW
Atlanta, Georgia 30303 USA

Rad Art: A Journey Through Radiation Treatment represents the author's personal experience with breast cancer through her paintings and comments. This book is a supplemental resource for cancer patients and survivors and their families and friends. The content of this book is not official policy of the American Cancer Society and is not intended as medical advice to replace the expertise and judgment of a cancer care team.

Manufactured by Dickinson Press, Inc.
Manufactured in Grand Rapids, MI, in June 2012
Job # 4046300

Printed in the United States of America
5 4 3 2 1 12 13 14 15 16

Library of Congress Cataloging-in-Publication Data
Loughridge, Sally Ives, 1945-
 Rad art : a journey through radiation treatment / written and illustrated by Sally Loughridge.
 p. cm.
 ISBN 978-1-60443-092-9 (hardback) -- ISBN 1-60443-092-3 (hardcover)
 1. Loughridge, Sally Ives, 1945---Health. 2. Breast--Cancer--Patients--Rehabilitation. 3. Breast--Cancer--Patients--United States--Biography. 4. Breast--Cancer--Radiotherapy. 5. Art therapy. I. Title.
 RC280.B8L59 2012
 616.99'4490092--dc23
 [B]
 2012009643

AMERICAN CANCER SOCIETY
Managing Director, Content: Chuck Westbrook
Director, Cancer Information: Terri Ades, DNP, FNP-BC, AOCN
Director, Book Publishing: Len Boswell
Managing Editor, Book Publishing: Rebecca Teaff, MA
Senior Editor, Book Publishing: Jill Russell
Book Publishing Coordinator: Vanika Jordan, MSPub
Editorial Assistant, Book Publishing: Amy Rovere

For more information about cancer, contact your American Cancer Society at **800-227-2345** or **cancer.org**.

Quantity discounts on bulk purchases of this book are available. For information, please contact the American Cancer Society, Health Promotions Publishing, 250 Williams Street NW, Atlanta, GA 30303-1002, or send an e-mail to trade.sales@cancer.org.

To all those living with cancer,
and to the superb medical professionals who cared for me

To my husband, Stephen Busch,
and to my children, Elizabeth and Nathaniel,
for their loving support

Foreword
by Eve Ensler

Cancer is so deep in the body.
Like oil in the earth. Like the unconscious
In the psyche. It is inside the inside of cells.
Sometimes scalpels can cut it. Sometimes
Radiation can zap it. Sometimes chemo can burn it.
Sometimes meditation can melt it and yoga can release it.
It lives where poems and paintings begin.
It lives so deep it writes its own story, draws its own
horizons.

After my cancer operation, when I came home from the hospital where they removed many organs and rearranged others, I needed to paint. I had never painted before. I needed my friends and family to paint with me. When they came to my loft, I knew they were afraid and awkward. I would hand them a crayon or a paintbrush or pastel. I asked them to draw me a vision. Being asked to draw or paint, without fail, terrorized people more than my cancer. It made them regress, but then we could play and speak in another language. I put the many paintings on a shelf and gathered them as the months of chemo went on. There was so much color and energy in these paintings. They became flags of the country I was traveling toward.

These *Rad Art* paintings by Sally Loughridge are psychic inscriptions, colored illuminations that come straight from her body. They are healings. They are prayers. They are radiant offshoots. They are gorgeous. Her body is speaking, calling up her own survival, calling up the exquisite beauty that can only be burned out of suffering.

Eve Ensler is a Tony award–winning playwright and activist. Her plays include The Good Body, O.P.C., Necessary Targets, *and* The Vagina Monologues, *which has been published in 48 languages and performed in over 140 countries. She is the founder of V-Day, the global movement to end violence against women and girls, which has raised over 85 million dollars. Her new play* Emotional Creature *will premiere Off Broadway in 2012. She lives in Paris.*

Preface

The oil paintings in this book are a visual recording of my emotional journey during daily radiation treatments for breast cancer. Initially, I strongly resisted the option of radiation. I had already undergone surgery to remove the cancer, and it appeared to be successful. I was also afraid of the potentially harmful long-term side effects associated with radiation. However, the traits of my tumor and the recurrence statistics made radiation therapy a prudent choice.

During the time between my cancer diagnosis and the start of radiation, I experienced a rush of powerful emotions. I could not always name them, but I felt them intensely in my body. After my surgery and knowing radiation would soon begin, I decided I would create a small painting every day following my treatment. As an artist, I hoped I would find solace, distraction, and release through this process.

Each treatment day, I took a blank panel from my stack of thirty-three and made a quick five-by-seven-inch painting. By intention, none took longer than twenty minutes to complete, and none was composed ahead of time. The paintings themselves were not intended to be art per se; rather, the process of creating them was the critical element in my coping strategy. This ritual helped steady me and, at times, surprised me. I recognize now that the paintings are a reflection of my overall cancer experience. They are not just about the radiation.

When I began to show the sequence of paintings to friends, cancer survivors, and health care professionals, they strongly encouraged me to share my work with other cancer patients and their support networks. At first, I wondered whether others could relate to the emotional path I had traveled. I wasn't even certain I wanted to tell my story in a public way. But as a retired clinical psychologist, I knew that one person's openness can ease another's pain and decrease isolation and fear. Among my close friends, the rich quilt of intimate conversation always brings relief, connection, and support. And so, I decided to share my experience.

Each person's cancer story is unique, yet common emotions weave throughout the community of those impacted by cancer. I offer these paintings in the hope that they may encourage self-expression and sharing in survivors as they heal and move forward in their lives.

Acknowledgments

I am deeply grateful to the medical professionals in Maine who diagnosed my cancer and treated and cared for me with such compassion, skill, and availability. They were patient with my questions, understanding of my fears, and respectful of my own way of getting through this unexpected journey.

I would particularly like to thank my breast surgeon, Melinda Molin, MD, for her expertise and understanding. I was well tended by her sensitive staff, including Elizabeth Huebener, RN, BSN, CDT, at Breast Care Specialists of Maine, a department of Mercy Hospital. During radiation therapy at the Coastal Cancer Treatment Center, which is a part of Maine Medical Center, my radiation oncologist, Celine Godin, MD, MPH, followed me with quiet wisdom, empathy, and humor. The team of radiation therapists offered a comforting mix of warmth and precision.

I am also grateful to those family members, friends, fellow survivors, and professionals who have encouraged me to publish this book and helped to nudge it along the way. My sincere thanks to the American Cancer Society for support of this project and especially to Rebecca Teaff, managing editor of Book Publishing, and Len Boswell, director of Book Publishing, for their sensitivity and professionalism in bringing it to publication. Finally, my appreciation to Jill Dible, for her simple, yet elegant book design.

Introduction

These thirty-three paintings are arranged chronologically—from the first to the last day of my radiation treatment. Each painting appears along with the words I wrote after completing it.

Your own experience with cancer—as a survivor, family member, friend, or professional—will influence how you relate to this book.

Here are a variety of ways to use *Rad Art*:

▶ Initially view the paintings in sequence without reading the accompanying words. Let the art trigger your own thoughts and feelings without the influence of my words.

▶ View each picture together with its corresponding words to gain an understanding of my experience and how it may resonate with or differ from your own.

▶ Use the paintings as a catalyst for personal sharing, conversation, and connection with your family and friends.

▶ If you are undergoing radiation treatment, view each painting and its accompanying words in concert with your own treatment schedule, one day at a time.

▶ If you are a family member or friend of a cancer survivor, share this book with your loved one as a resource to encourage and support self-expression.

▶ If you are a health care professional, use this book to better understand the power, diversity, and fluidity of emotions that often parallel the physical experience of a cancer diagnosis and treatment.

▶ Find another way of using *Rad Art* that is uniquely yours.

Day 1

MY RIGHT BREAST

I had always thought of my breasts as a matched pair. But since I received a diagnosis of breast cancer, they have become distinctly individual. I am anxious about starting radiation, and I feel protective of my right breast—in a familiar, motherly way. In this first painting, I am startled to see how dark the interior is, full of the mystery and menace of the cancer cells.

One treatment down, thirty-two to go! Six and a half weeks feels like a very long time. I am glad I have started this series of paintings, but I am not sure how my near-daily practice of studio painting will fare. I am already looking forward to my first weekend off treatment.

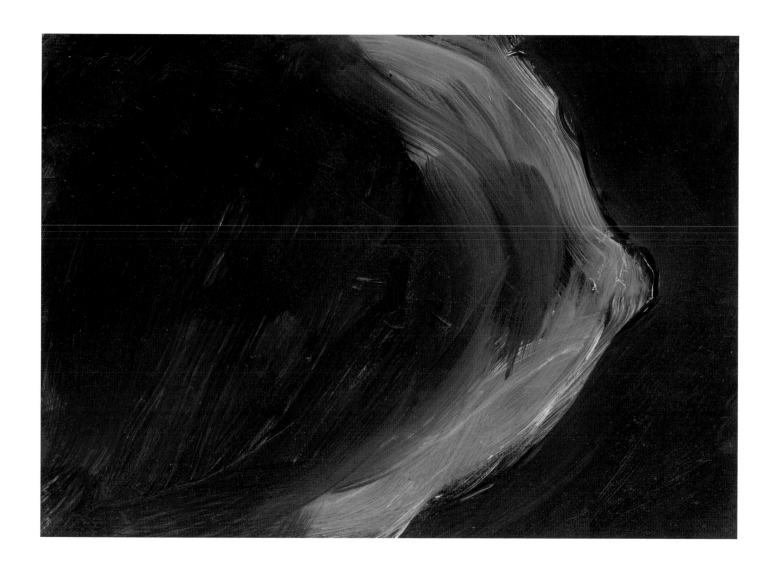

Day 2 MY TERRAIN

I started this painting full of raw emotions and uncertainty about the radiation process. Do I need it? Will it help me? Will it have long-term side effects? I am angry that I need more treatment, angry that I have cancer.

I loaded my brush with magenta and sculpted a mountainous terrain. The landscape quickly became my profile as I lay on the metal treatment table—arms over my head, and knees elevated. I have to assume a very exact position and remain still during the treatment so that the rays can be precisely focused on the target area mapped on my chest. The jagged cloud shapes in the painting are the radiation beams aimed at my breast, coming from a huge, circling, and humming apparatus over the table. I have already begun to count the clicks and movements of the machine.

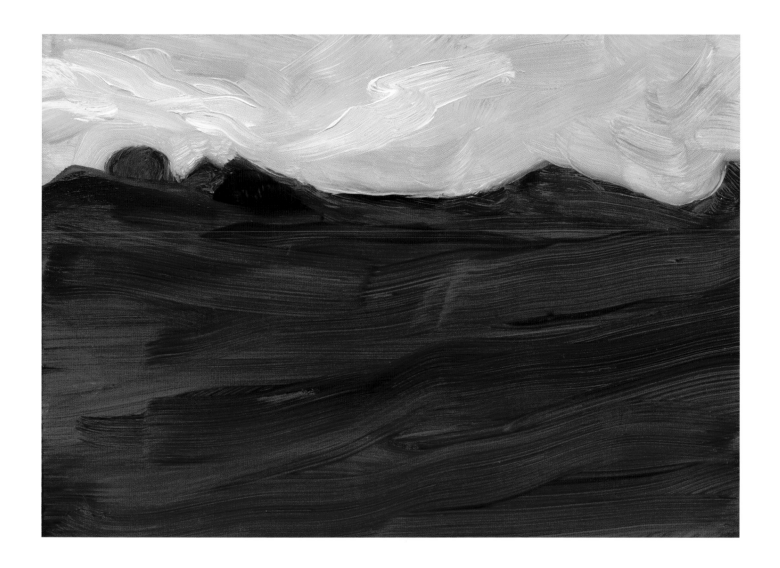

Day 3

LASER LOCK

This painting began as a deep purple field with three lasers angled downward. Soon I found myself adding my tattooed breasts. A few weeks ago, before the actual radiation treatments could begin, small permanent tattoos were made on each side of my breasts and in the sternum area. I had never really wanted a tattoo. Would I still like it at 80? But lately, my husband and I have fantasized about converting these little black dots into something more appealing—perhaps a garland of roses or hearts dancing across my chest.

These tattoos, together with the lasers, aid the radiation therapists in precisely lining me up for the treatment. This alignment is a strange and unknown process that I find unnerving. I hope it will soon become reassuring.

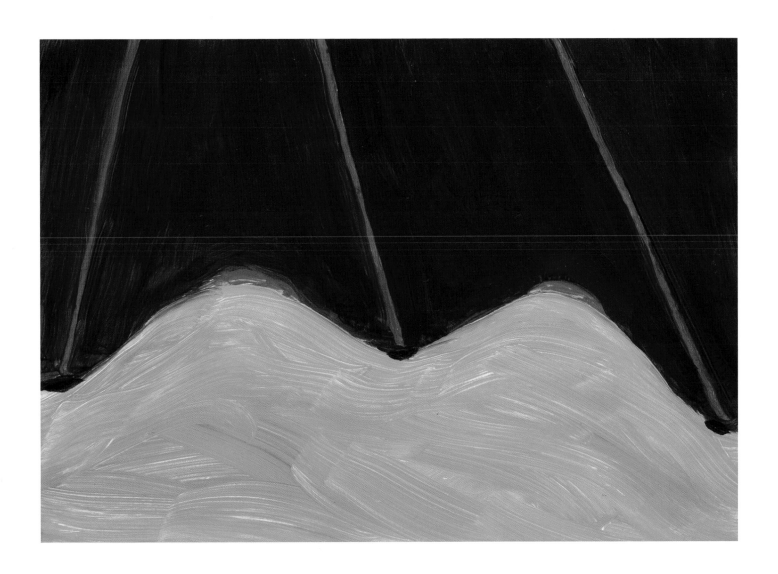

Day 4

FEELING SMALL

I had always felt healthy and strong, but the discovery that I had—perhaps still have—cancer has reduced my confidence and morale. This painting began as a little yellow ball, which quickly became me—my head down, my arms wrapped around my knees, and my breasts guarded. I added the red in engulfing, menacing strokes.

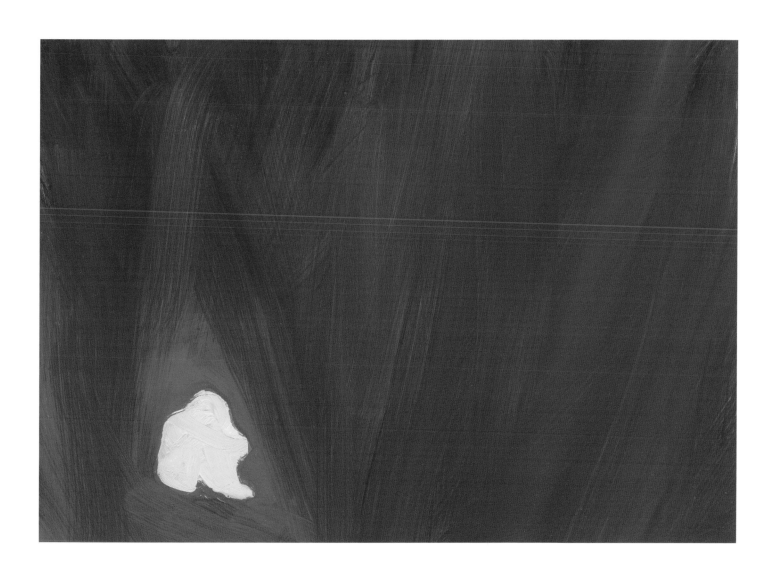

Day 5 SCAT!

For the last month, I have been trying to use visualization to imagine the cancer cells leaving my body. Looking at this painting, I see the yellow-green field as healthy cell growth while the cancer cells race to escape from my body. Scat!

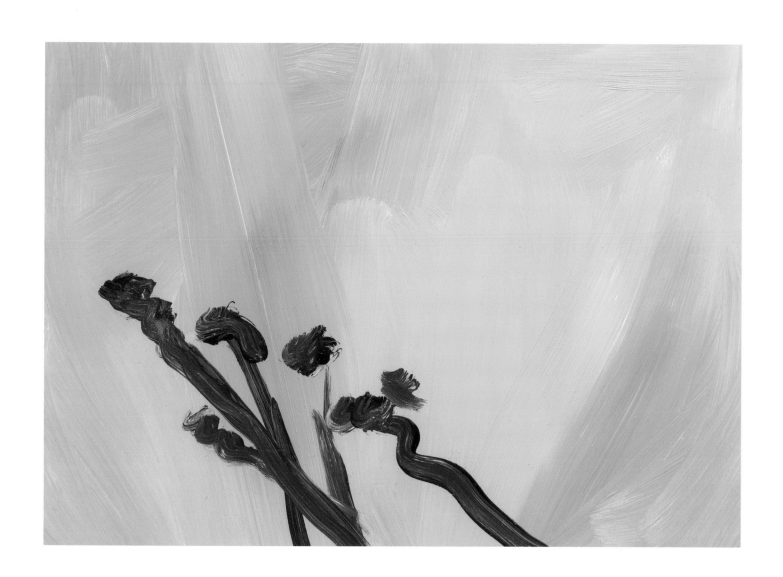

Day 6 SCAT II

I am still imagining healthy growth crowding out the bad cells. In this painting, the bad cells are weaker, smaller, and running for their lives. Yet, they seem almost human now. I have a weird moment of compassion for them.

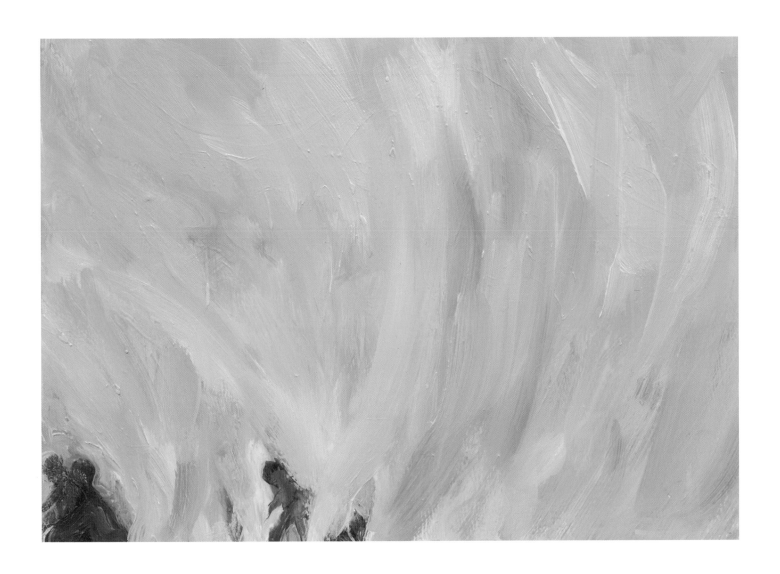

Day 7 LOW DAY

After my first weekend off, I resumed treatment yesterday feeling blue. This mood still grips me today. I don't like being this focused on myself or my body. It feels indulgent and weak. Despite having lots of love and support, I feel alone and apart.

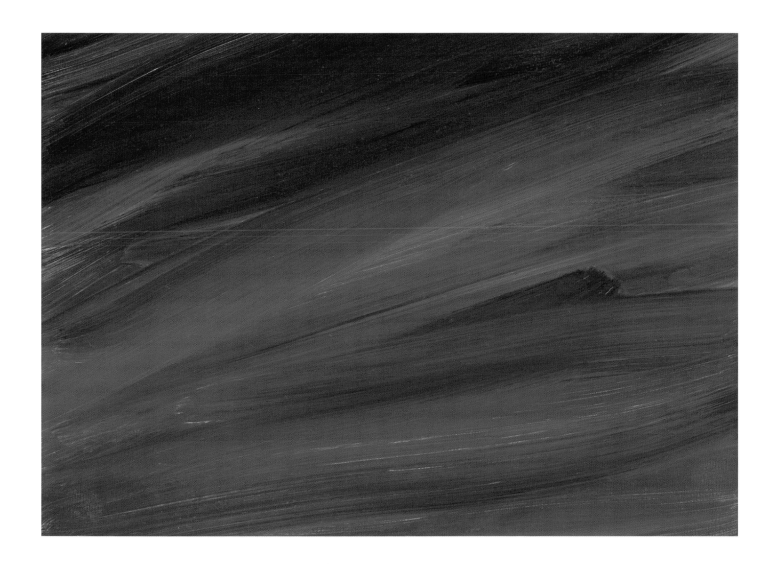

Day 8

BRIGHTENING

Today my emotional "sky" is clearing, but it's still such a lonely, barren landscape.

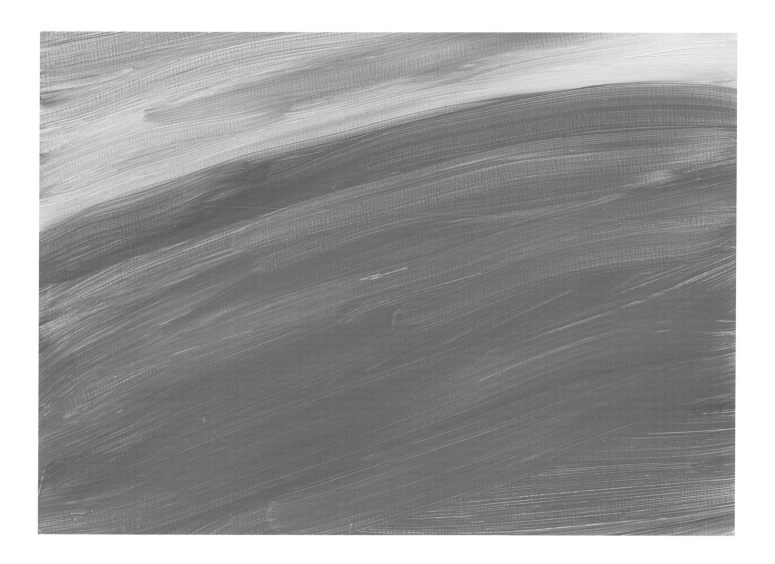

Day 9 ACTION!

When I began painting this morning, my palette was already filled with rich colors for a large landscape painting I am working on. I energetically laid every available hue on this small panel.

I can see the dark interior of my breast with brighter colors swirling around it. I can't feel anything happening inside me, but I am willing the cancer cells to die. To me, this painting represents the dynamic cellular activity that the radiation treatment is causing in my breast.

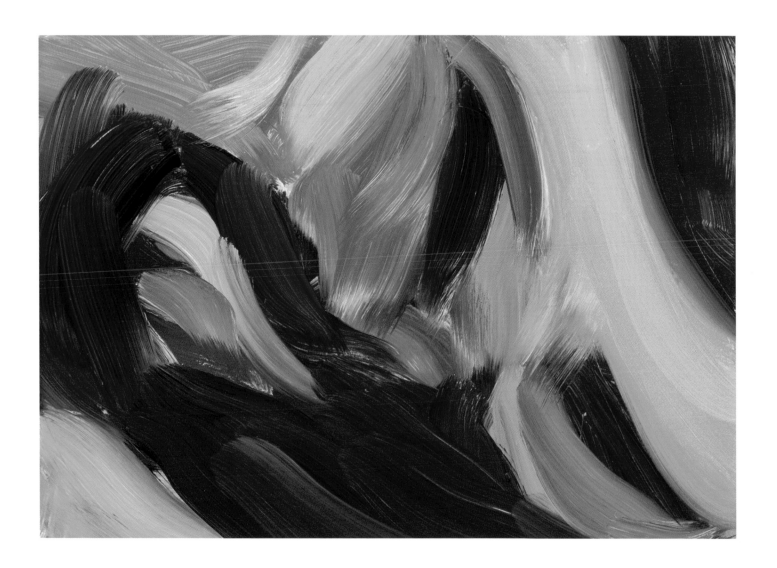

Day 10

TIT BOATS

As an artist living on the coast of Maine, I often portray the ocean with rich, blue-green hues. This painting began as an empty, lonely sea under a light sky. Soon, I found myself adding oddly shaped sails that grew nipples almost by themselves.

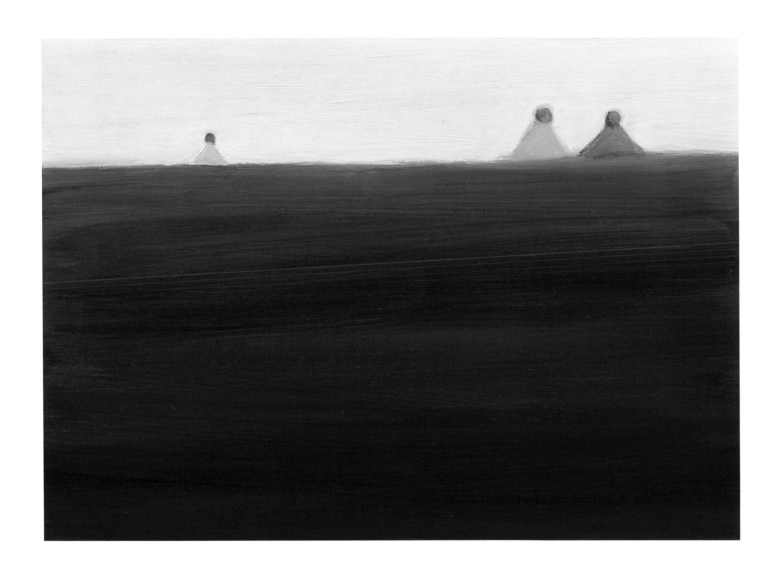

Day 11

OUT OF MY NOWHERE

Today's painting evolved into another seascape with islands and a sliver of warm light on the horizon. This scene reminds me of the type of work I usually create over a longer period. It feels good to have this quiet image float up "out of my nowhere" and not to make another picture of a cancerous breast or a scary procedure.

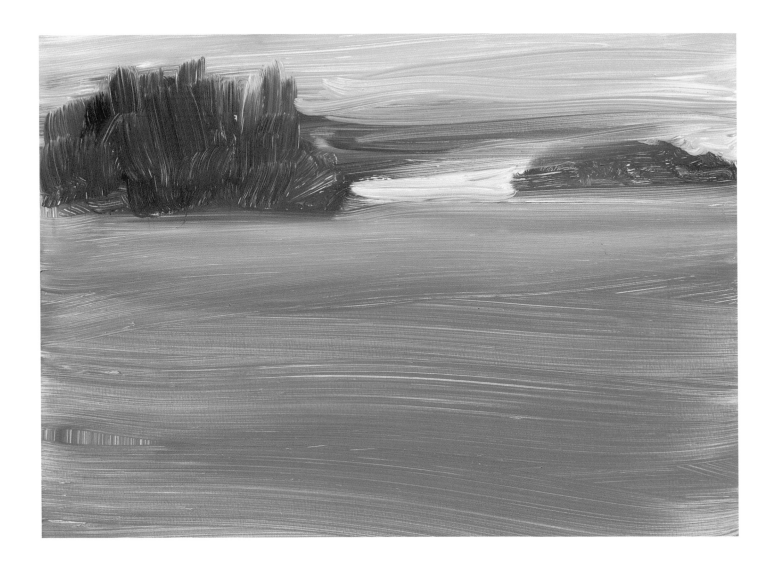

23

Day 12 RADIANCE

Still fighting my resistance to the treatment, I have been trying to focus on the positive aspects of radiation therapy. This childish rendering of the earth with a brilliant sun appeared quickly today. Or, perhaps, it is my breast with nipple aglow.

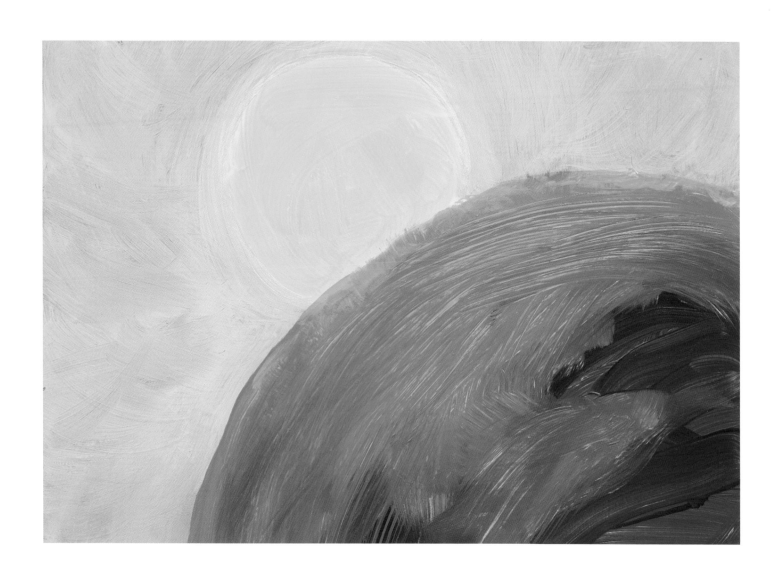

Day 13

LOOP DE LOOP

Every treatment is reassuringly the same—efficient and precise. But I am on an emotional roller coaster about the radiation process and, on a more basic level, about the cancer. Did the surgery remove all of the cancerous cells, or do I still have cancer? Not knowing is very hard. Feeling out of control is humbling and scary.

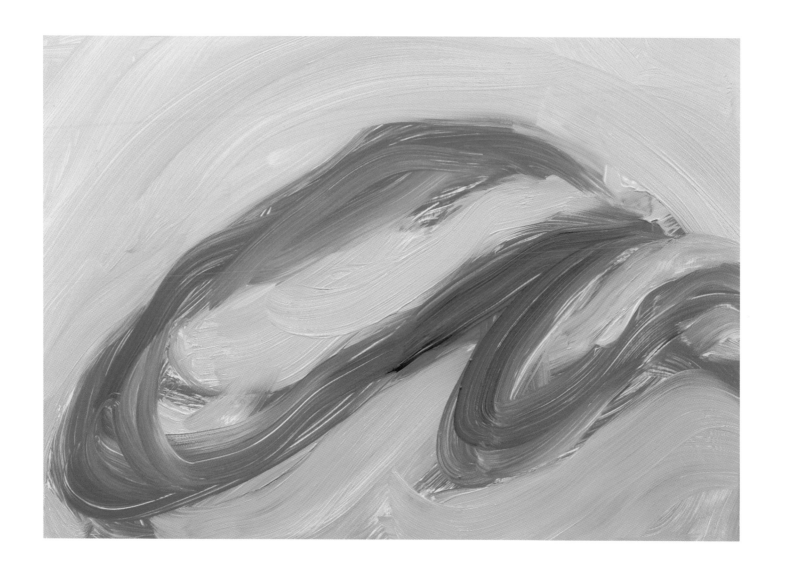

Day 14 WAY FORWARD

Today, I am feeling more positive and seeing my way more clearly through this rough patch. I am almost at the end of the third week of treatment. The halfway mark approaches.

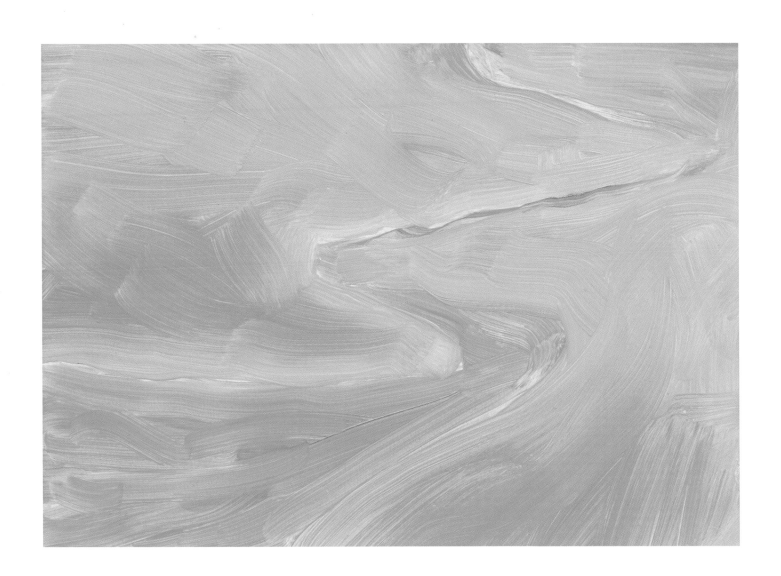

Day 15 HOPE

I began this painting without a conscious plan, but soon saw the emerging curved shape, moving from dark to light, as my breast. In a fluid, sure gesture from left to right, I quickly made the final brushmark. Making this stroke felt especially good. I feel a welling of hope and movement forward.

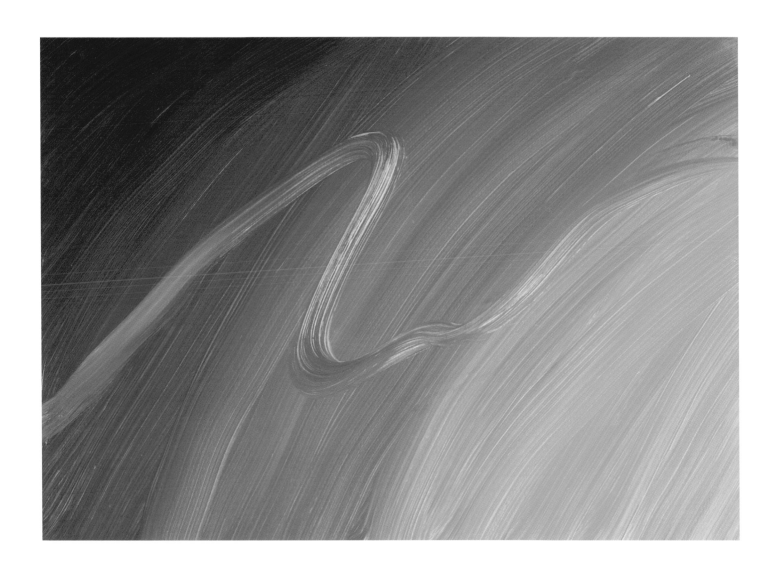

Day 16 4/5/45

Today is my sixty-fifth birthday. To ensure that the radiation is given in the correct location, I am asked to state my date of birth and thus confirm my identity before each treatment begins. Perhaps, this painting reflects a wish to return to my carefree younger days by the ocean. Yet I don't know if the clouds are moving in or out.

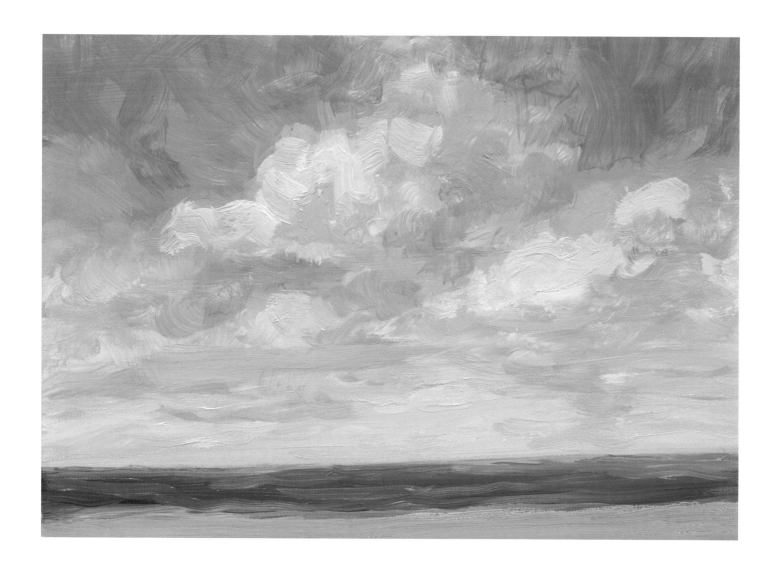

Day 17

BACK TO THE FUTURE

Seventeen is the absolute midpoint of my thirty-three treatments. Excited to be halfway through, I began this painting feeling positive. As I laid the blue in, the shape soon came to represent completed treatments. The arrow shows the way forward. It both surprises and unsettles me that the arrow appears to be bisecting a breast, no doubt my own. Apparently, my unconscious self aggressively grabbed hold of my brush. What does my future hold?

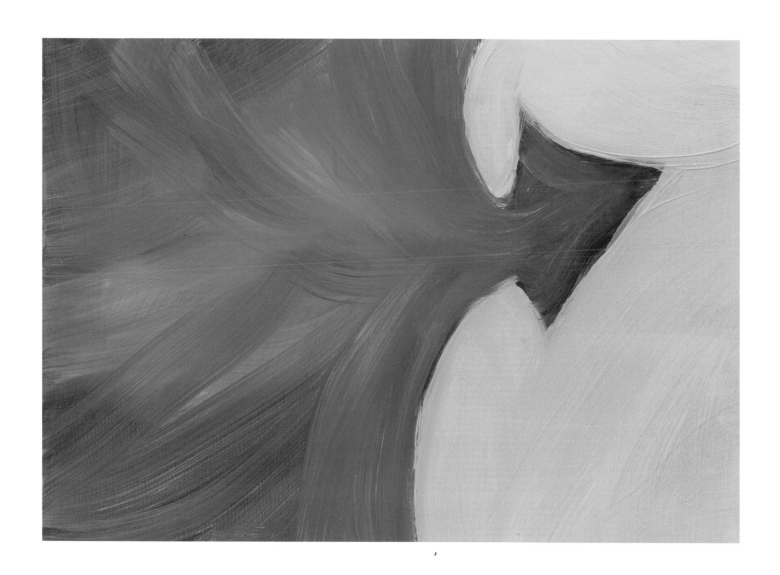

Day 18 ITCH!

My skin within the radiation field has become predictably redder and very sore. I had no idea how bothersome the itching would become, like mosquito bites many times over. I am using aloe several times a day for temporary relief and trying hard not to scratch.

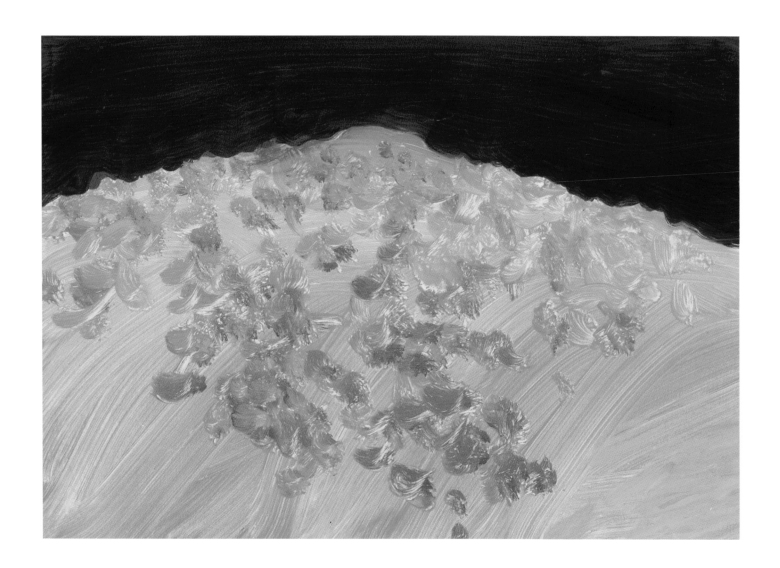

Day 19

SPRING FORWARD

The itch continues and my fatigue is growing. Outside, an early Maine spring has brought blooms to our garden. This painting began as radiation beams, but grew into a flower bursting forth. It is glorious to feel this good today.

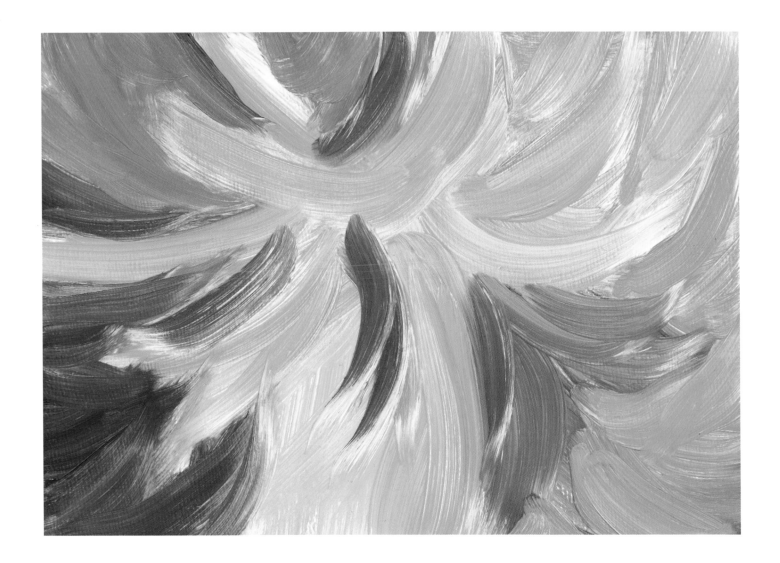

Day 20

FOG BREAK

As I painted this morning, a foggy scene appeared out of the dull, grey colors I was using. I am glad that light finally broke through the mist and haze.

Going to radiation therapy is now just part of my daily routine and feels less overwhelming. I take naps as I need them and allow myself time off from my art business whenever I want. I am anticipating the end of treatment and the approach of the summer season with renewed hope and optimism.

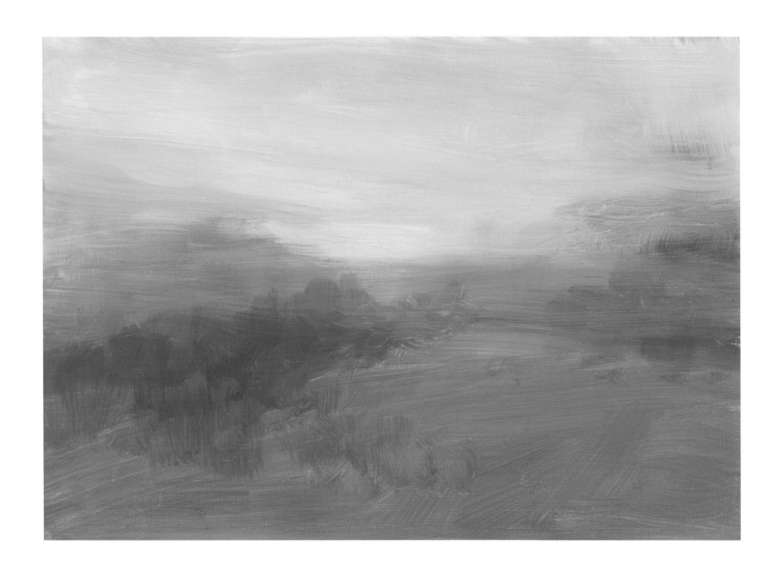

Day 21 DREAM WAY

I notice that I am now using lighter colors more often when I start my painting. This shape of mounded green gradually became a hillside field with a swath of wild flowers beckoning me forward. Happily, I am now focusing less on the cancer and more on how I can grow as an artist.

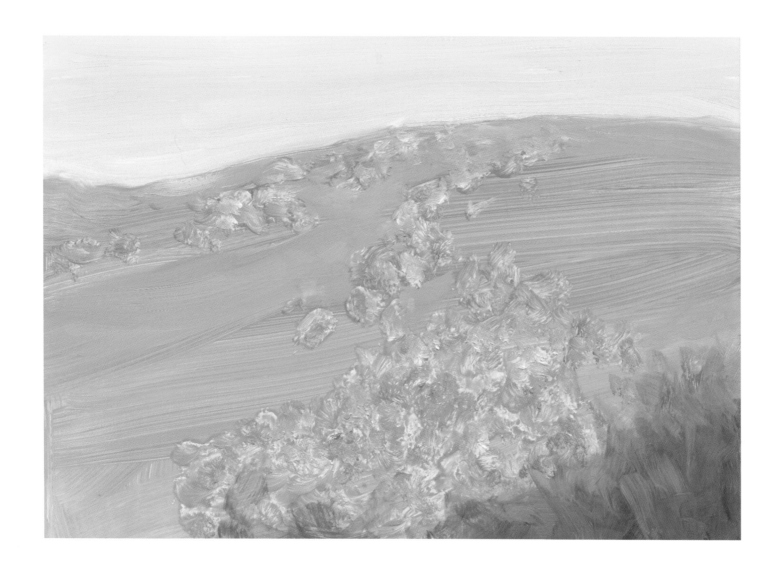

Day 22 SWIRLING

I had fun making these curves. Perhaps they represent both my breast and this unexpected journey. Cancer has challenged my body, my sense of self, and my outlook on life. I have always been attuned to nature, but I am even more so now. A shift of light and shadow, the grace of a bird's flight, or a scent in the air acutely engages me. Moments of connection and love fill me with gratitude. Carpe diem!

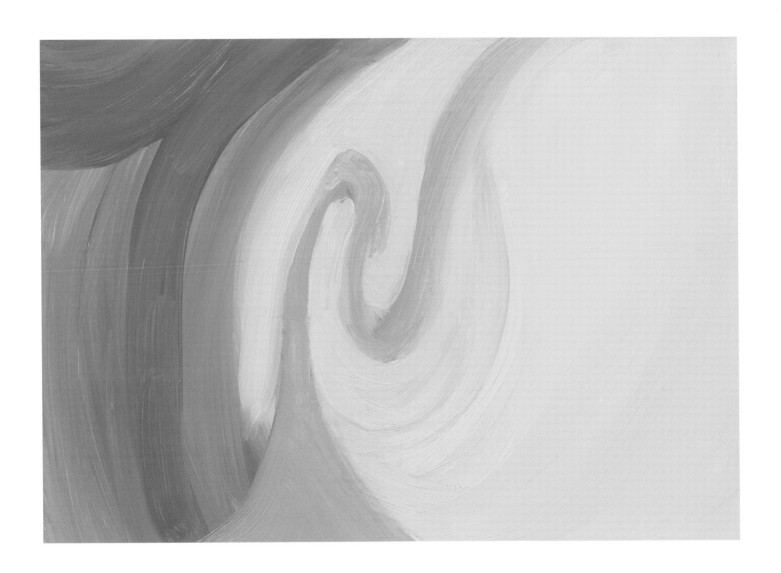

Day 23

FALLING STAR

When I picked up my brush today, I began making stars and then added the falling star, perhaps me—humbled, imperfect, vulnerable, tumbling yet still shining.

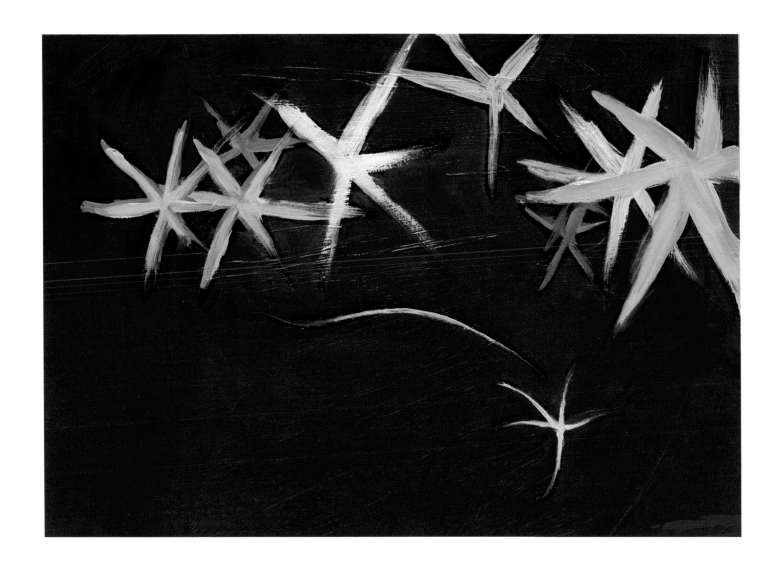

Day 24 **FLOAT**

I am feeling calm and peaceful today.

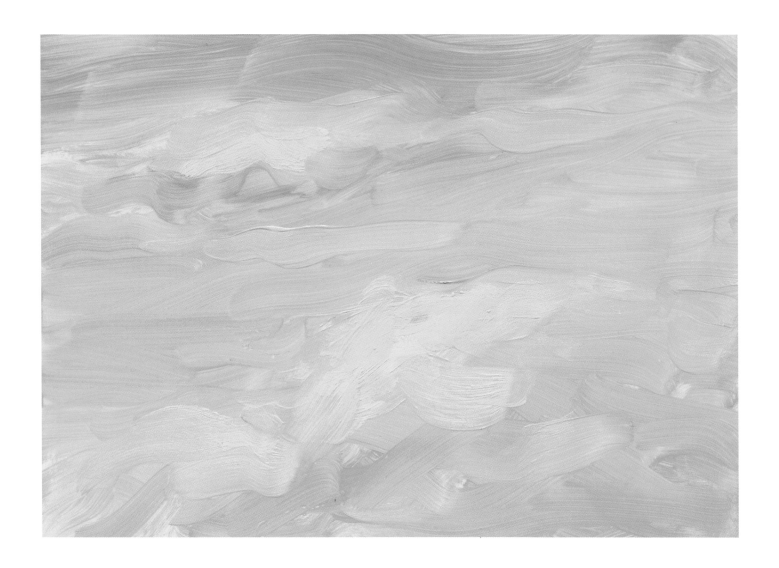

Day 25 OUCH!

The itch has become increasingly uncomfortable. The rash and pain are distracting, and it's getting the better of me today. I am not quite this red-orange, although it feels that way.

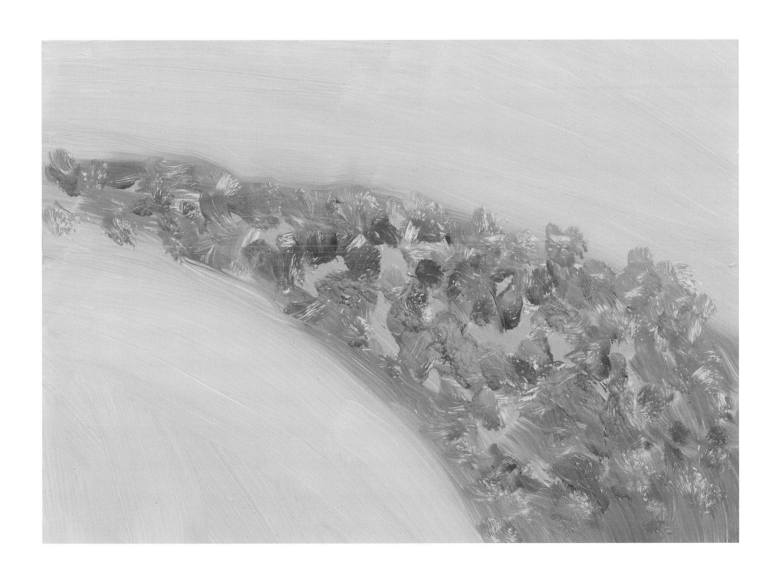

Day 26 BEYOND THE WOODS

I began this painting using very dark colors, but brightened it with sunlight over the fifteen minutes I worked. I have always liked to paint trees with a glint of light glancing through them or reflecting off the forest floor. Perhaps the sun in this picture represents my growing recognition that treatment will soon be over.

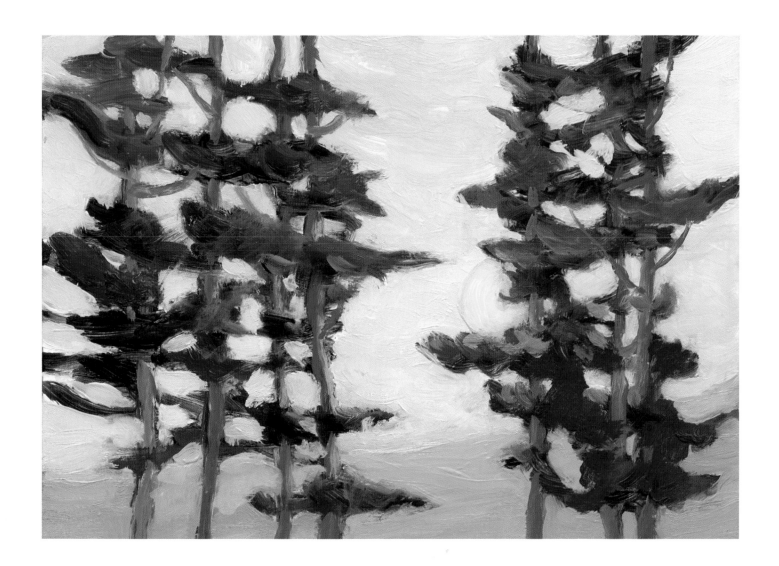

Day 27 PEACE

I visited friends today after my treatment and saw a vast stretch of a saltwater farm, once a dairy operation, now an oyster farm. The serenity of the scene—field, marsh, and river—brings me great calm and peace. I want to hold on to these feelings.

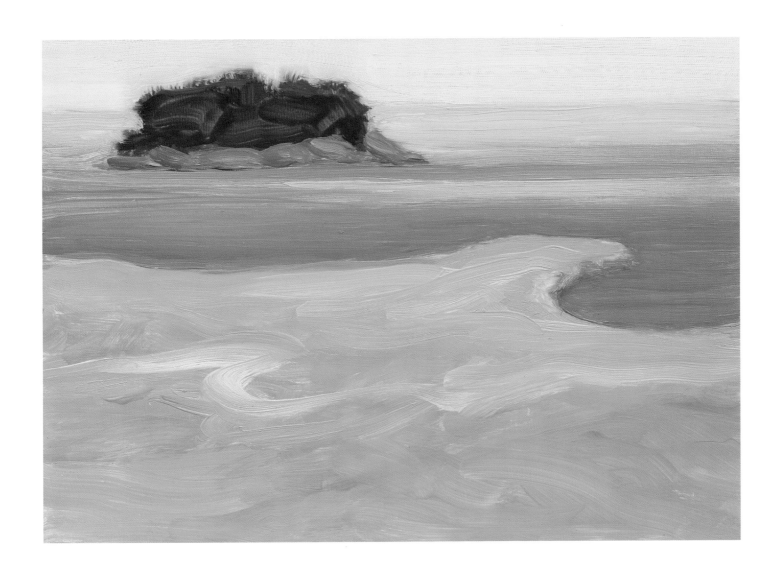

Day 28 INNER WORK

Today, I began by having fun with color. Yet, as I painted, I started thinking about the ongoing cellular activity in my breast—the cancer cells dying and healthy cells regenerating. The initial delight of making colorful shapes soon disappeared. I found myself vigorously reinforcing these shapes with my paintbrush, as if trying to change my actual cell structure. I feel vulnerable and scared.

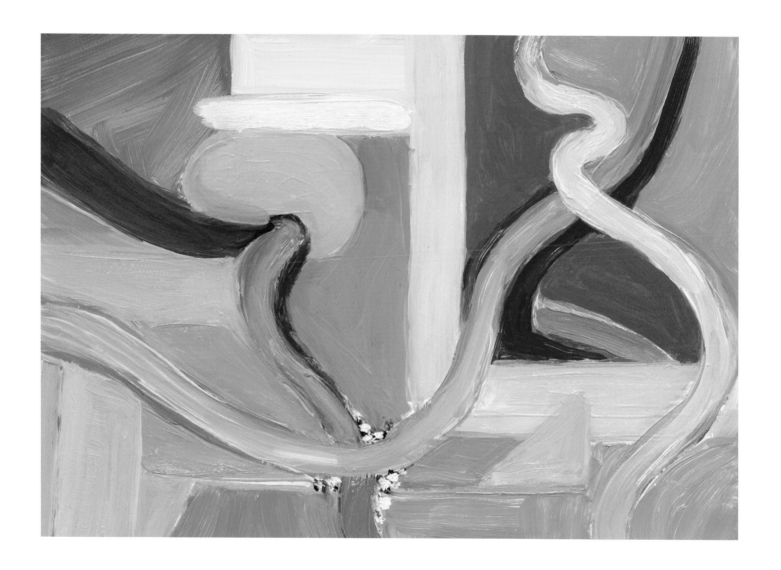

Day 29 FOCAL ZAP

Four treatments to go. The last five are called focal or "boost" radiation to the tumor's original site. I am grateful that the full breast radiation is over because it has caused so much skin irritation and discomfort. In this painting, I portray the "boost" as a warm, restorative beam.

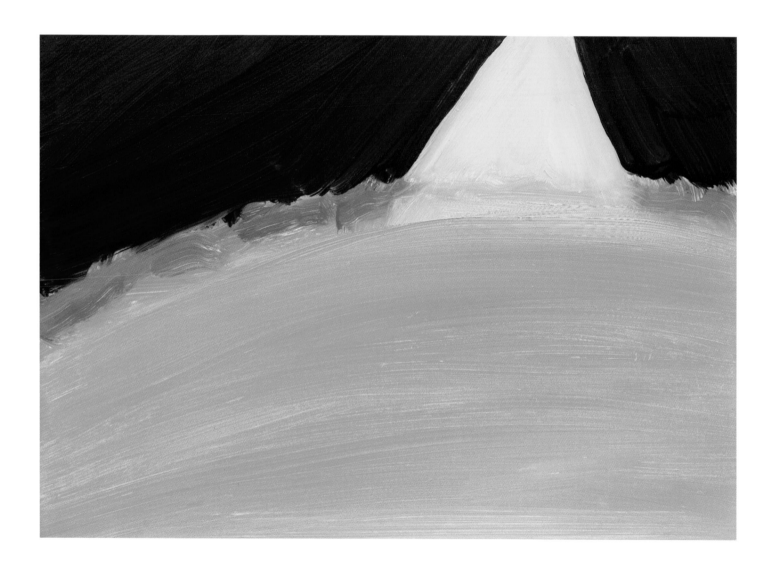

Day 30 STORM BREAK

This painting reminds me of my annual stays on Monhegan Island, with five friends and fellow artists. The island has long been a mecca for painters, both renowned and unknown. Its hearty community, rocky terrain, and shifting seas continually intrigue me. Cancer, too, has a robust community—of patients, survivors, caregivers, and health care professionals—to face its challenges with courage. I am feeling more a part of that community now, and buoyed by its spirit.

Three treatments to go! I am surprised that this picture is relatively dark, yet relieved that the light is breaking through the clouds. I do not like the radiation process, but knowing I will soon be on my own without daily medical treatment and support makes me feel a little shaky. As I resume my full active life, I know it will be with a new sense of vulnerability, shadow of uncertainty, and deepened appreciation of each moment.

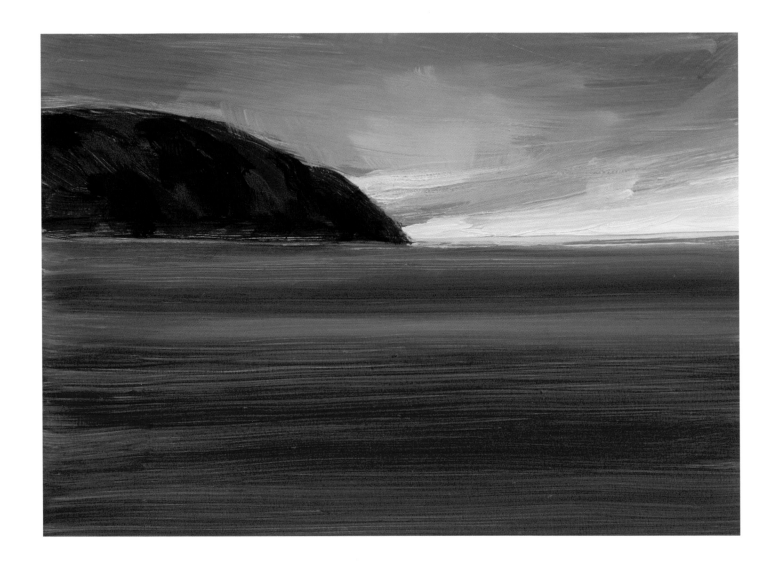

Day 31 CURVES AHEAD

I felt playful and curious as I made these overlapping arcs. I'm not sure what's around each curve, but, today, I am feeling more confident and positive.

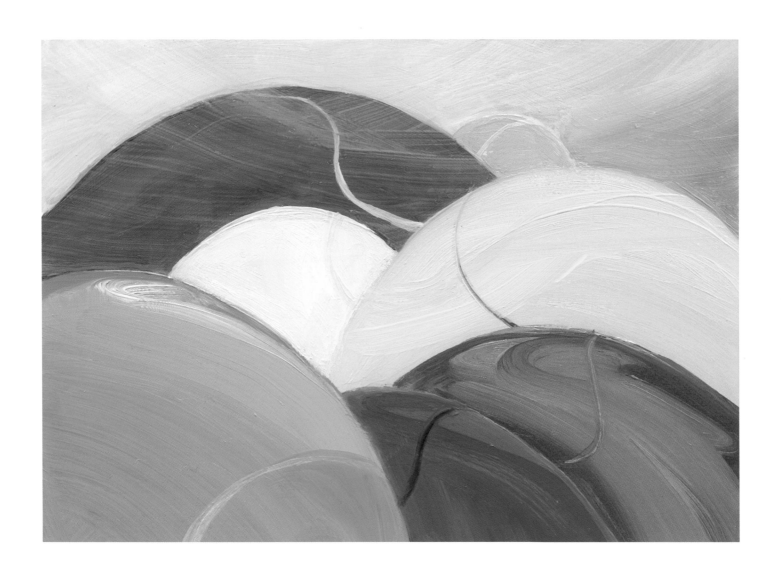

Day 32 SUNRISE

With one treatment left, it feels as if a new day is breaking after four dark months of anxiety and uncertainty. And yet my painting looks overworked and too deliberate. I think I am trying too hard today to be upbeat.

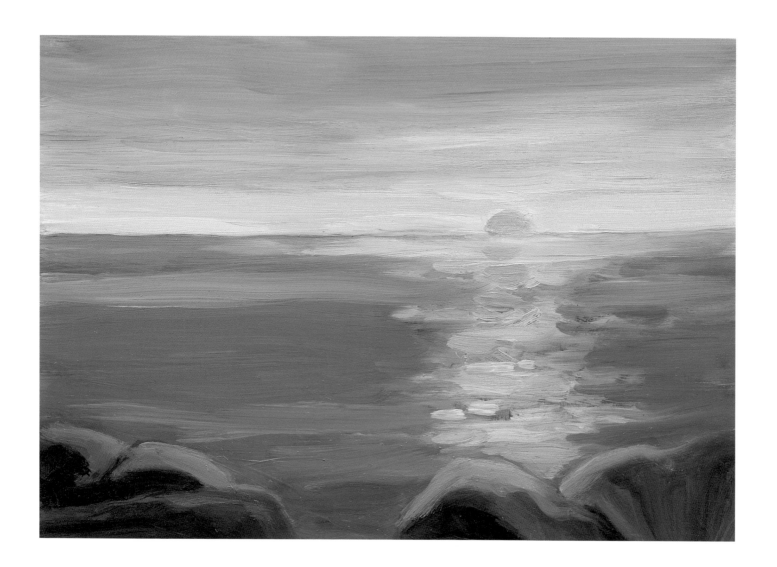

Day 33

GOOD MORNING

Radiation treatment is over! Today, I spread the paint around like I was richly buttering my bread. I feel a surge of joy and anticipation of life ahead.

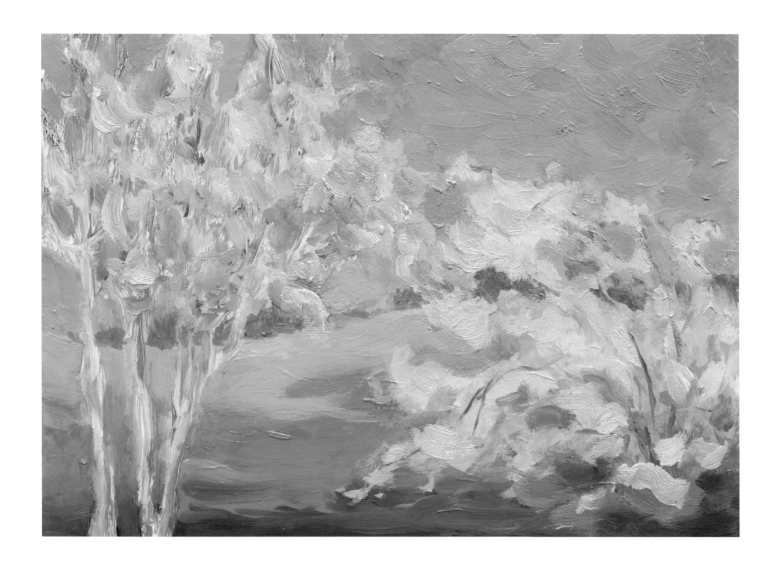

Afterword
by Sally Loughridge

Looking at these paintings again, I feel some of the same tough emotions I experienced during treatment: fear, vulnerability, anger, uncertainty, and sadness. These feelings fortunately are now less frequent and far less intense. Breast cancer remains in my consciousness at a bare simmer rather than a raging, uneven boil.

My paintings remind me of my cancer journey—from the moment of diagnosis through surgery and radiation—and the raw, overwhelming feelings that were often hard to express in words. Through the planned routine of making these paintings, I regained a greater sense of self-control and understanding. For others, writing poetry, keeping a journal, playing music, sculpting clay, or using another mode of expression may help as painting has helped me.

The rush and fluctuation of these intense emotions after my diagnosis contributed to my sense of losing my balance. There is no precise formula for how to weather a cancer diagnosis and course of treatment, but looking back, I realize that certain elements helped to steady and heal me. Finding a cancer care team whom I trusted was critical to both my physical and emotional recovery. Usually very independent, I gratefully accepted support from a caring network of family, friends, and professionals. Acknowledging pain and fear increased my sense of vulnerability, but it also brought me empathy and aid. I welcomed the many acts of kindness toward me, whether small, awkward, or grand.

Over time I recognized that my powerful, unfamiliar emotions were normal in such a new, scary situation. Sharing my story with trusted family and friends decreased my sense of isolation. I kept up my usual connections and contacts as much as possible. Humor—theirs and mine—was essential to keeping my spirit strong. I laughed and cried, each in its own time.

When I could not find words to convey my feelings accurately, I turned to art. Making daily "radiation" paintings gave me a structured outlet emotionally. As much as possible, I continued the regular activities that bring me pleasure and a sense of purpose, particularly art-making, reading, friendships, and being outdoors. Trying to find my balance again and greater ease with what I was experiencing, I became even more finely attuned to nature's rhythms and my place within them.

My once typical pattern of high activity, interaction, and optimism was often jarred by my fatigue and health worries. I learned to be more gentle with myself by allowing space for a slower tempo, greater rest, and vacillating emotions. I began to set goals that were more attainable under the circumstances I was now in, rather than those I was accustomed to before my diagnosis.

Over this last year, my renewed optimism and increased physical energy have mutually enhanced one another. I am now able to set more ambitious personal goals; at the same time, I have become more sensitive to what really matters to me. Bolstered by health and joy, I feel strong and steady again. I hope that these *Rad Art* paintings resonate with you and will serve as a catalyst for self-expression, validation, and the sharing of feelings. Warm wishes for healing and resilience!

AMERICAN CANCER SOCIETY PROGRAMS AND SERVICES

The American Cancer Society is the nationwide, community-based voluntary health organization dedicated to eliminating cancer as a major health problem by preventing cancer, saving lives, and diminishing suffering from cancer through research, education, advocacy, and service. Headquartered in Atlanta, Georgia, the Society has 12 chartered Divisions, more than 900 local offices nationwide, and a presence in more than 5,100 communities. The American Cancer Society provides educational materials, information, and patient services. A comprehensive resource for all your cancer-related questions, the Society can also put you in touch with community resources in your area.

American Cancer Society
Toll-free number: 800-227-2345
Web site: cancer.org

Cancer Survivors Network®
http://csn.cancer.org
The Cancer Survivors Network (CSN) is an online community by and for people with cancer and their families. Find and connect with others through a member search, discussion boards, chat rooms, and private CSN e-mail. Create your own personal space to tell others about yourself, share photos or audio, start an online journal (blog), contribute resources, and more.

Road to Recovery®
The Road to Recovery program provides rides to patients who have no way to get to cancer treatment.

Hope Lodge®
Getting the best care sometimes means cancer patients must travel away from home. This can place an extra emotional and financial burden on patients and caregivers during an already challenging time. Each Hope Lodge offers cancer patients and their families a free, temporary place to stay when their best hope for effective treatment may be in another city. Currently, there are thirty-one Hope Lodge locations throughout the United States. Accommodations and eligibility requirements may vary by location, and room availability is first come, first served.

TLC
The "tlc" magalog is the American Cancer Society's catalog and magazine for women. It offers helpful articles and a line of products made for women with cancer. Products include wigs, hairpieces, breast forms, bras, hats, turbans, swimwear, and accessories. All proceeds from product sales go back into the American Cancer Society's programs and services for patients and survivors.

Reach to Recovery®
For more than forty years, the American Cancer Society Reach to Recovery program has helped people (female and male) cope with their breast cancer experience. Reach to Recovery matches trained volunteers with people dealing with breast cancer and its effects through face-to-face visits or by phone. Volunteers are trained to give support and up-to-date information, including literature for spouses, children, friends, and other loved ones.

I Can Cope®
The American Cancer Society I Can Cope cancer education classes can help patients and their loved ones learn about cancer and how to take care of themselves.

Look Good...Feel Better®
Look Good...Feel Better is a free, non-medical, brand-neutral, national public service program created to help individuals with cancer look good, improve their self-esteem, and manage their treatment and recovery with greater confidence. In a Look Good...Feel Better session, trained volunteer cosmetologists teach women how to cope with skin changes and hair loss using cosmetics and skin care products donated by the cosmetics industry.

Look Good...Feel Better for Teens
Look Good...Feel Better for Teens is a unique, free program for teenage cancer patients aged 13 to 17. It helps them cope with how cancer treatment and side effects can change the way they look. The program addresses the needs of both boys and girls.

Patient Navigator Program
The Patient Navigator program helps patients, families, and caregivers navigate the many systems needed during the cancer journey. Trained Patient Navigators at cancer treatment centers link those dealing with cancer to needed programs and resources. Patients can talk one-on-one with a patient navigator about their situation.

NATIONAL ORGANIZATIONS AND WEB SITES

This list provides other selected resources that may be helpful to cancer patients and families seeking inspiration, stories, and strategies for emotional support and self-care during the cancer experience of diagnosis, treatment, and moving forward.

Academy for Cancer Wellness
Phone: 520-722-4581
Web site: cancerhealth.org

American Breast Cancer Foundation
Toll-free number: 877-323-4226
Web site: abcf.org

American Society of Plastic Surgeons (ASPS)
Phone: 847-228-9900
Web site: plasticsurgery.org

Breast Cancer Network of Strength (formerly Y-Me National Breast Cancer Organization)
Toll-free number: 800-221-2141
Toll-free number (Spanish): 800-986-9505
Web site: networkofstrength.org

CancerCare, Inc.
Toll-free number: 800-813-4673 (Counseling)
Web site: cancercare.org

Cancer Community Center
Toll-free number: 877-774-2200
Web site: cancercommunitycenter.org

Cancer Hope Network
Toll-free number: 800-552-4366
Web site: cancerhopenetwork.org

Centers for Disease Control and Prevention (CDC)
Toll-free number: 800-232-4636
Web site: cdc.gov

Food and Drug Administration Consumer Information Line
Toll-free number: 888-463-6332
Web site: http://www.fda.gov

LIVESTRONG Survivor Care Program
Toll-free number: 866-236-8820
Web site: livestrong.org

Maine Cancer Foundation
170 US Route 1, Suite 250
Falmouth, Maine 04105
Phone: 207-773-2533
E-mail: info@mainecancer.org

Men Against Breast Cancer
Toll-free number: 866-547-MABC (6222)
Web site: menagainstbreastcancer.org

National Breast Cancer Coalition
Toll-free number: 800-622-2838
Web site: stopbreastcancer.org

National Cancer Institute
Toll-free number: 800-4-CANCER (800-422-6237)
Web site: cancer.gov

National Coalition for Cancer Survivorship (NCCS)
Toll-free number: 888-650-9127
Web site: canceradvocacy.org

Patient Advocate Foundation
Toll-free: 800-532-5274
Web site: www.patientadvocate.org

Patrick Dempsey Center for Cancer Hope & Healing
Toll-free number: 877-336-7287
Web site: dempseycenter.org

SHARE: Self-Help for Women with Breast or Ovarian Cancer
Toll-free number: 866-891-2392
Web site: sharecancersupport.org

Dr. Susan Love Research Foundation
Toll-free number: 866-569-0388
Web site: dslrf.org

The Wellness Community
Phone: 202-659-9709
Web site: cancersupportcommunity.org

ABOUT THE AUTHOR AND ARTIST

STEPHEN BUSCH

Sally Loughridge, PhD, has drawn and painted since early childhood. After
nearly thirty years of working as a clinical psychologist, she turned to creating
art full-time. She paints, studies, teaches, and exhibits her art along the coast
of Maine. During her recent cancer experience, Sally embraced painting
as a natural mode of self-expression. She attributes a deepening of her
artwork and self to the emotional journey of facing a life-threatening illness.

PRAISE FOR *RAD ART*

"These works are soulful, vibrant, descriptive, provocative, and thoughtful."

—Elizabeth Huebener, RN, BSN, CDT,
breast center nurse educator

*"Sally's depiction of her radiation therapy experience is illuminating to me as a doctor,
and I hope that all who read this are as enlightened."*

—Celine Godin, MD, MPH, radiation oncologist

*"Rad Art beautifully illustrates how creative self-expression can bring comfort, meaning, and richness to
even the most negative and fear-arousing events of our lives. The book elegantly describes a personal—
yet classic—journey through darkness back into light, and the growth that can result."*

—Shelley Carson, PhD, lecturer in psychology, Harvard University;
author of *Your Creative Brain: Seven Steps to Maximize Imagination,
Productivity, and Innovation in Your Life*

*"Loughridge provides a visual interpretation of a daily process that I often tried to translate through words.
Her paintings vary dramatically and in wonderful ways, mirroring the emotional shifts she went through.
Rad Art is moving and compelling and should be distributed to cancer centers everywhere."*

—Susan Conley, cancer survivor,
author of *Foremost Good Fortune*

*"It is sometimes very difficult to find a way to express what having cancer means emotionally and psychologically. Often we just want to get
through it as quickly as possible. Sally's art and observation remind us that there is beauty and hope in adversity. I think anyone undergoing
this, or with someone who is, will want to own and pore through the book because it is simultaneously so frank and so beautiful."*

—Daphne Lehava Stern, cancer survivor,
hospice team bereavement and volunteer coordinator

*"Through these elegant, expressive paintings, Sally Loughridge makes her particular radiation journey universal. This tiny volume
illuminates the way that a creative spirit offers strength in times of adversity. It speaks to those of us who have 'been there/done that,'
but has as much or more to offer those who are anxiously waiting to begin the journey and those who prescribe the treatment."*

—Alice F. Chang, PhD, cancer survivor;
president and founder, Academy for Cancer Wellness;
and author of *A Survivor's Guide to Breast Cancer*